Gary Grasshopper
Battles a Bully

Written by Connie Amarel
Illustrated by Swapan Debnath

ISBN 978-1-61225-099-1

Published by Mirror Publishing
Milwaukee, WI 53214

Printed in the USA.

This book is dedicated to best friends everywhere who are always there when we need them, especially my friend from first grade, Dr. Kathleen Burnick-Plawky, who is truly the best in every way. It is also dedicated to my good friends, Dr. Alan Weber and Lena Difasi, for their wonderful and much appreciated input. Lastly, it is dedicated to my incredible family, Mike, Michele and Chris, my mom June and brother Dave, for their endless love and support.

Gary Grasshopper anxiously looked out the window, watching for the mail to be delivered. As soon as he saw the mailman, he hopped as fast as he could to the mailbox. He was hoping there would be a letter from his best friend, Freddie Firefly. Gary planned to visit Freddie during Spring Break and Freddie was going to send directions to his house.

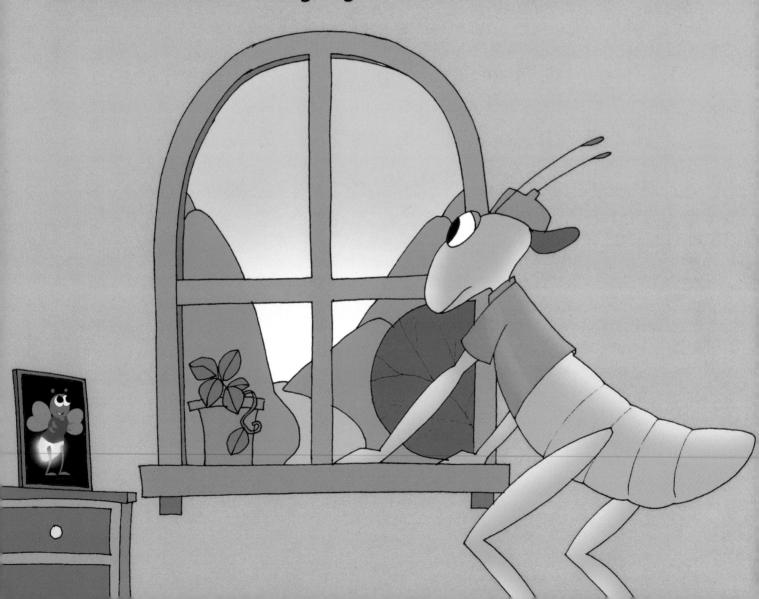

Gary happily hopped back to the house, ripped open the envelope and started reading. His smile quickly changed to a frown, as Freddie had written that he was having some problems in school and that maybe Gary should wait until summer to come and visit.

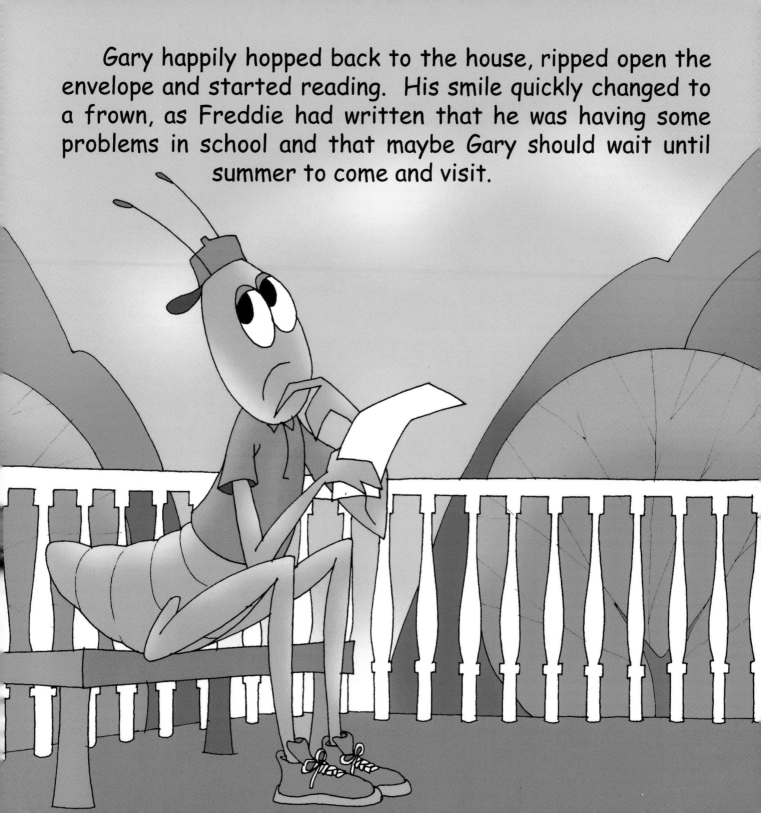

Something didn't seem right about Freddie's letter and Gary decided to go and visit him anyway. He was sure that his friend really needed him right now.

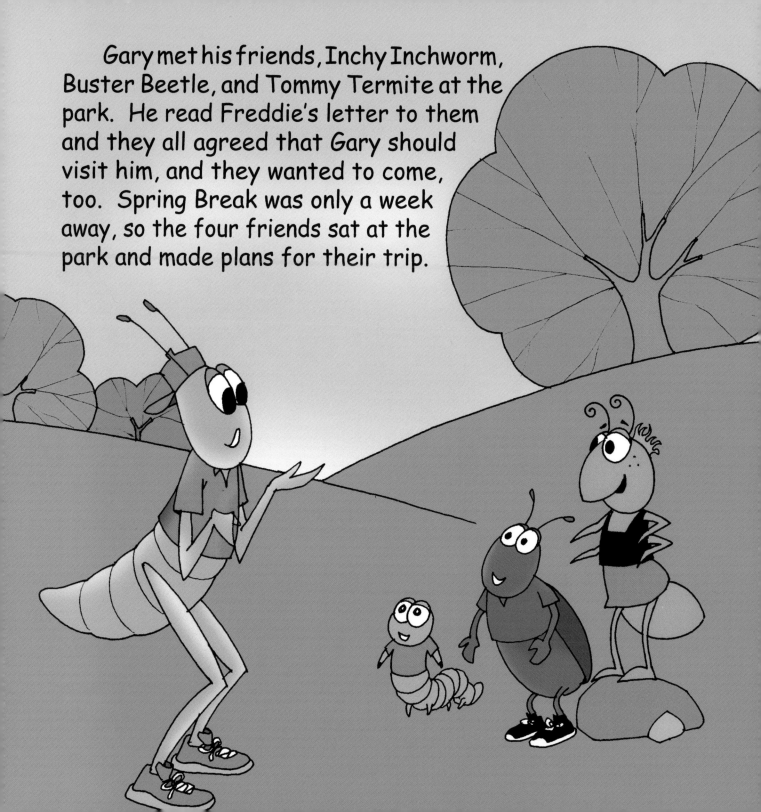

Gary met his friends, Inchy Inchworm, Buster Beetle, and Tommy Termite at the park. He read Freddie's letter to them and they all agreed that Gary should visit him, and they wanted to come, too. Spring Break was only a week away, so the four friends sat at the park and made plans for their trip.

They were happy to see Betty Butterfly at the park with her boyfriend, Chris Caterpillar. They asked her for directions to Freddie's house, which she was happy to give them. Soon it was Spring Break and the friends left early in the morning to go to Freddie's house. Gary couldn't wait to see his best friend again.

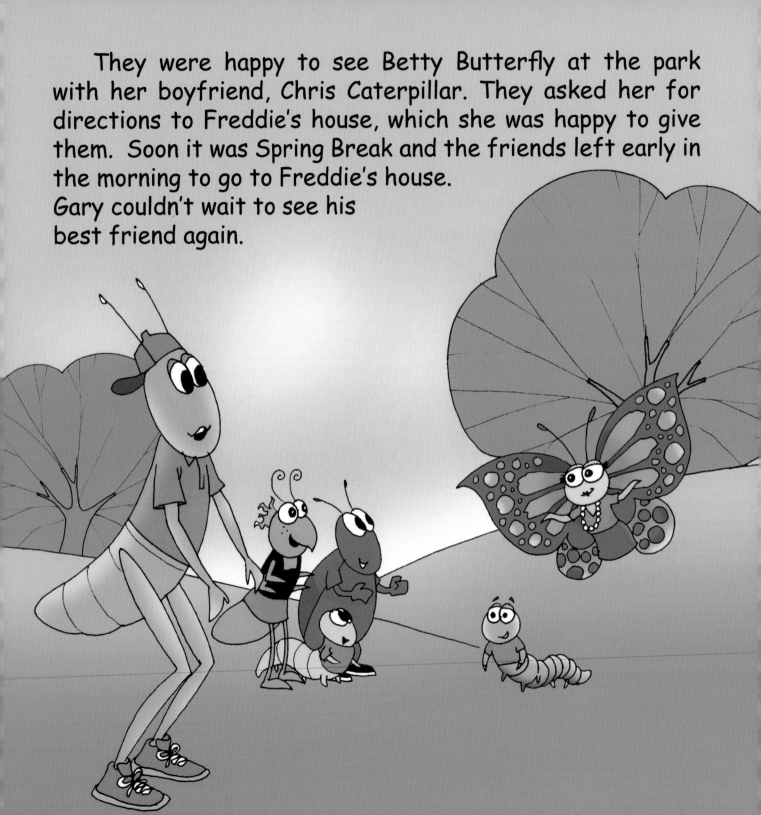

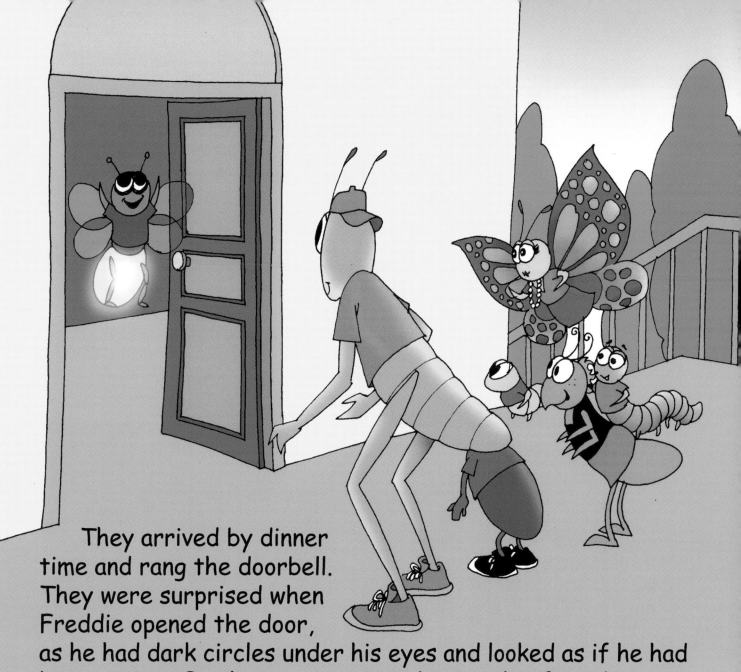

They arrived by dinner time and rang the doorbell. They were surprised when Freddie opened the door, as he had dark circles under his eyes and looked as if he had been crying. But he was so excited to see his friends again, especially his best friend Gary. They all hugged and then decided to order a pizza as they were very hungry.

They sat on the living room floor eating pizza and catching up on what they had been doing since Freddie moved away. Gary asked Freddie how he liked his new school and noticed that Freddie looked really sad again, so he changed the subject. They made plans for what they were going to do tomorrow.

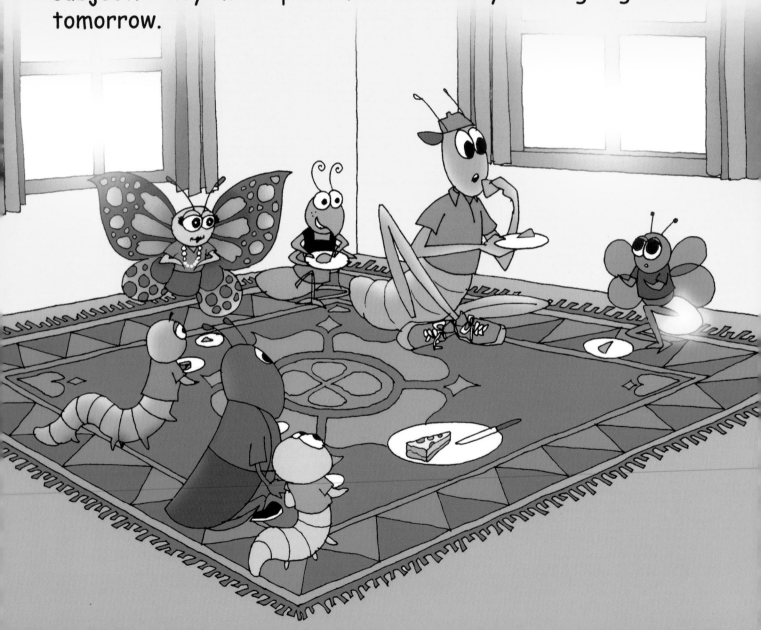

Buster, Inchy, and Tommy slept in a spare bedroom and Gary slept in Freddie's room. He was glad to get some time alone with Freddie because he knew that Freddie would tell him what was wrong. At first Freddie was embarrassed and didn't want to talk about it, but when he saw the love and concern in his best friend's eyes, he couldn't hold it in any longer.

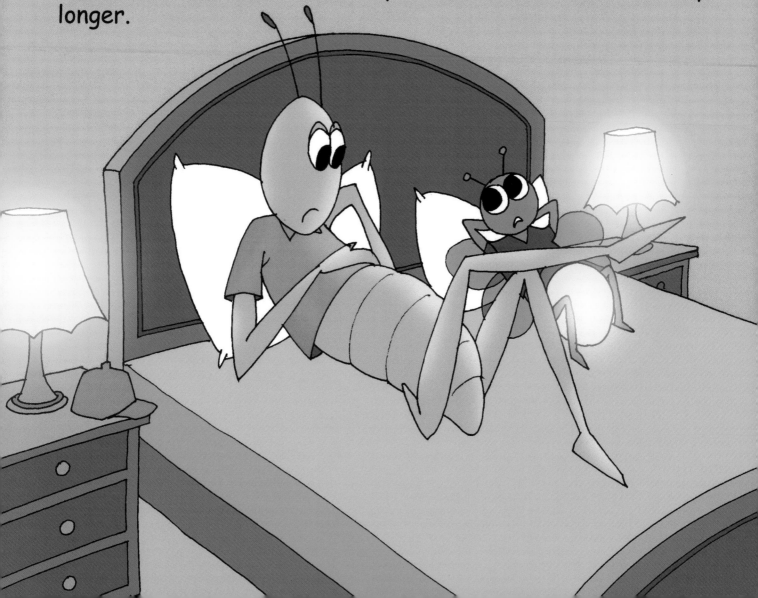

Freddie told Gary that at first he liked his new school and made some really nice friends. But one student, Carl Cockroach, didn't like him because he thought Freddie was too small and because he had moved from a field that was different from this field.

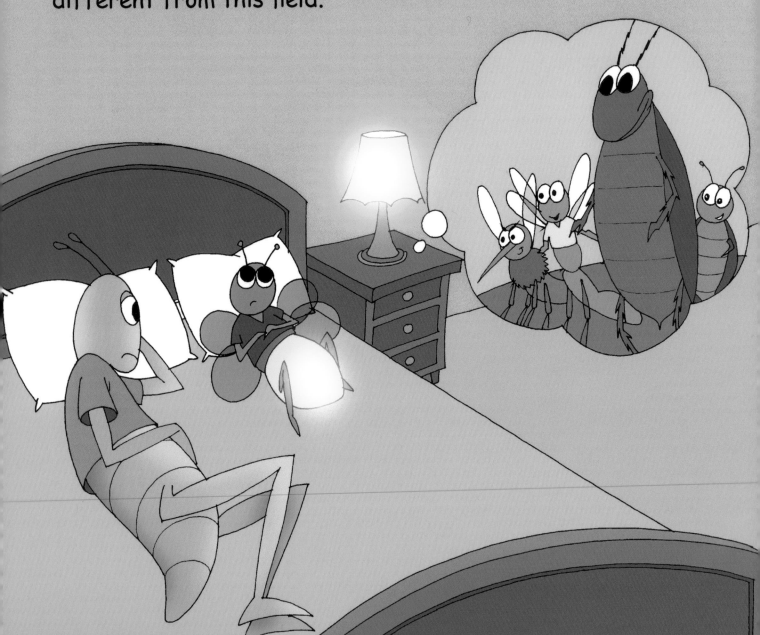

Carl was a bully who would call Freddie names in front of the other students. He told lies about Freddie and made fun of him. He would chase Freddie and try to make him stumble and fall.

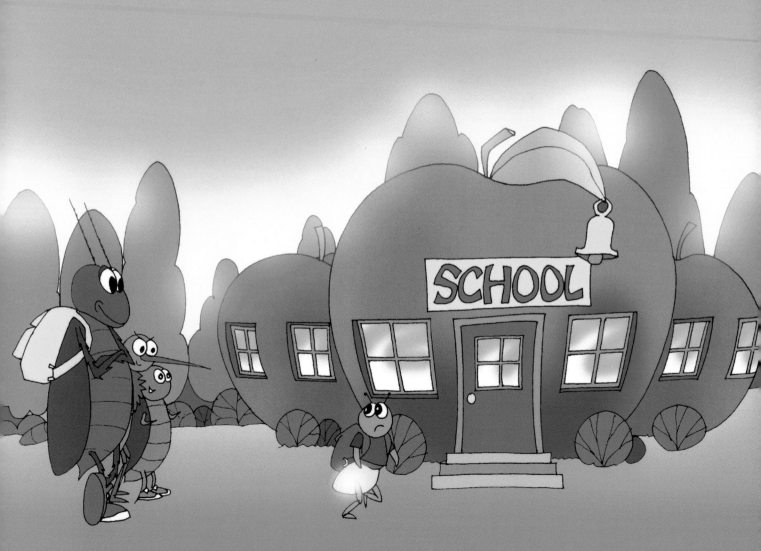

Freddie said that at first the friends he had made didn't believe the lies that Carl Cockroach told, but eventually these friends began to believe the lies, too. Soon no one would talk to Freddie or sit with him at the lunch table. The other students would laugh when Carl bullied him and made fun of him.

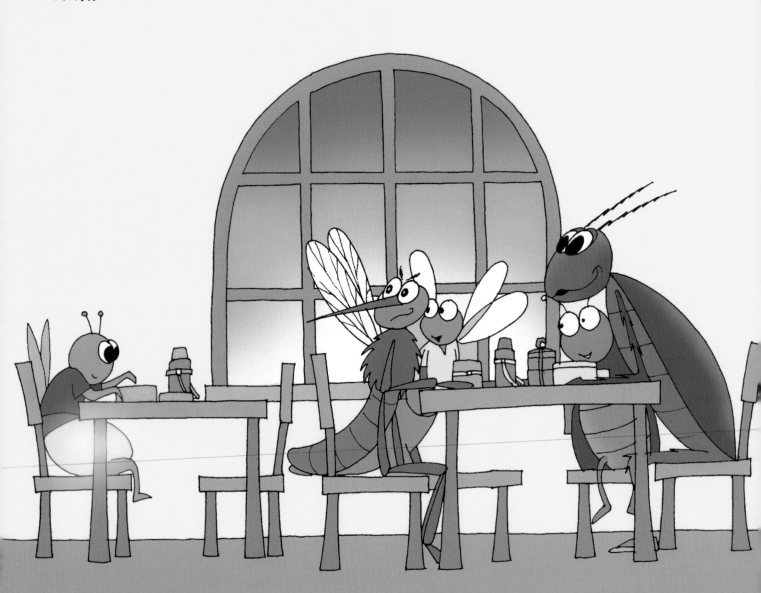

Even Missy Mosquito, who Freddie had a crush on, stopped hanging out with him at recess. Freddie told Gary he was so sad and lonely that he had decided he didn't want to go back to school. Hearing the awful things that were happening to his friend made Gary very angry.

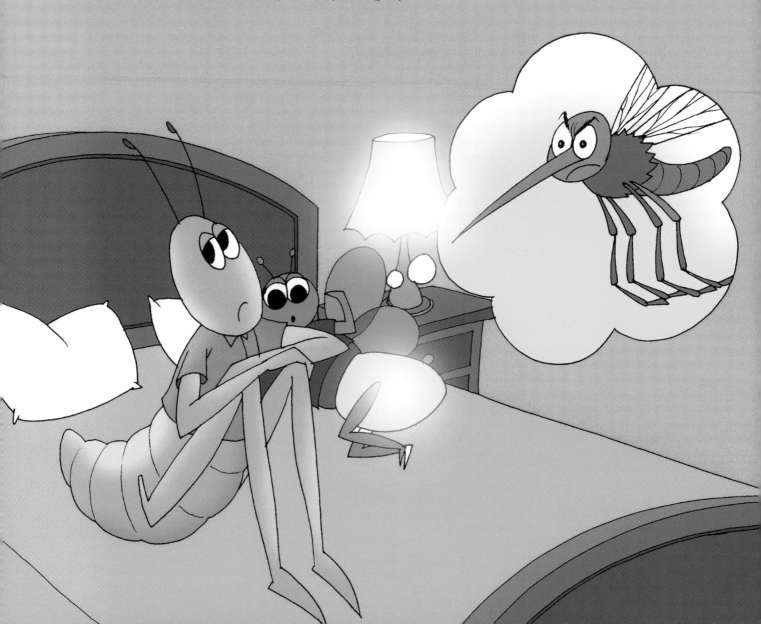

Gary told Freddie that he wanted to meet this bully and asked Freddie if he knew where he could find him tomorrow. Freddie said Carl was always at the park and that he avoided going to the park just for this reason. Gary told Freddie he was going to the park tomorrow to try to find Carl.

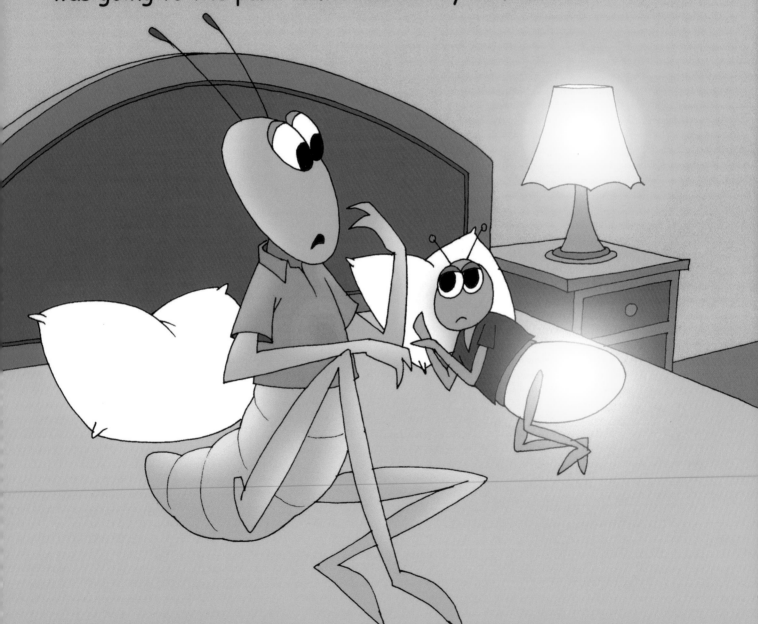

In the morning Gary told Inchy, Tommy, and Buster about Carl Cockroach and how he had bullied Freddie. They were also upset about this and wanted to go to the park as well. They finished eating breakfast and headed for the park.

When they got there, Freddie pointed out Carl Cockroach. He was surrounded by some other students and when he saw Freddie, started taunting him and making fun of him while the other students laughed. He then rushed toward Freddie like he was going to chase him, but Gary hopped in between the bully and Freddie and stood tall.

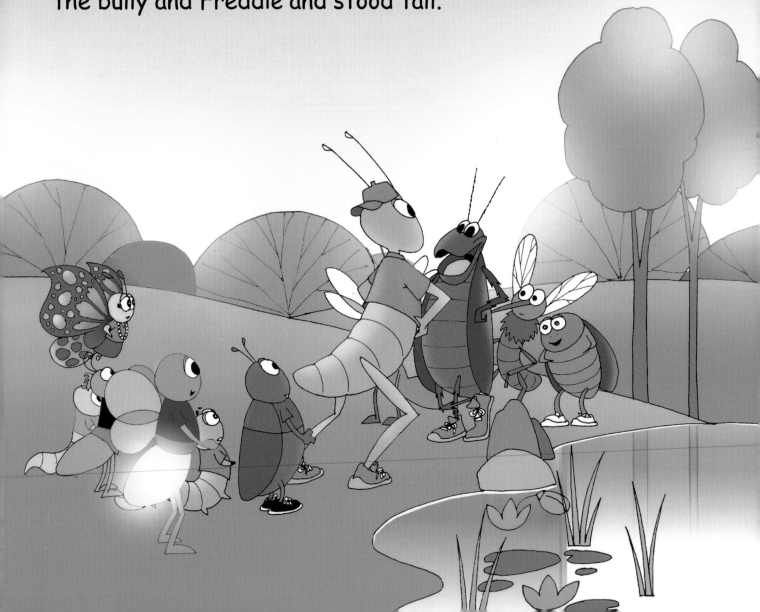

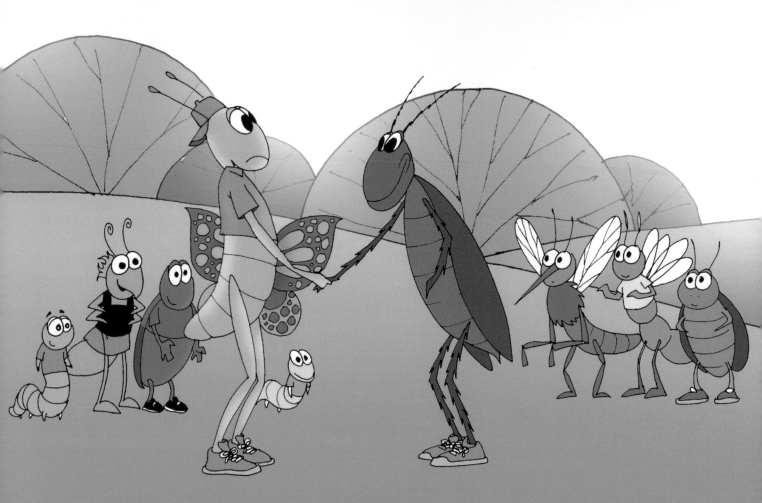

The other students stopped laughing and stood silently, watching to see what would happen. Carl looked closely at Gary, then suddenly snapped his fingers. "Hey, I know who you are. You're Gary Grasshopper and you can jump higher than any other grasshopper in the valley. You are so cool!"

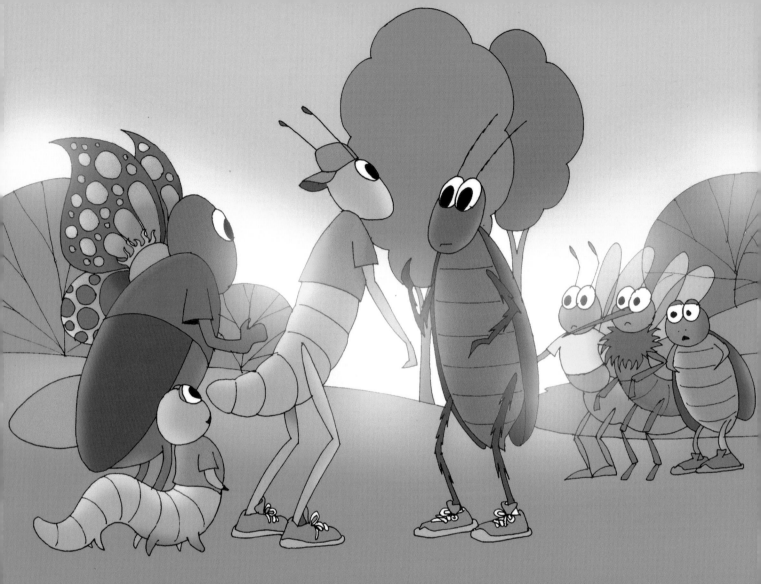

Gary told Carl, "You know what's not cool? Being a bully and making fun of somebody, taunting them and telling lies about them just because they're different." Then he said to the students who were watching, "It's also not cool to stand by and do nothing when a bully does this to another student."

"Back where I live everyone is aware that the reason someone bullies another person is because they are insecure and need to do this to feel better. At my school the students know that if someone bullies another student, to tell the bully that this is mean and despicable behavior, that they don't like it and won't tolerate it."

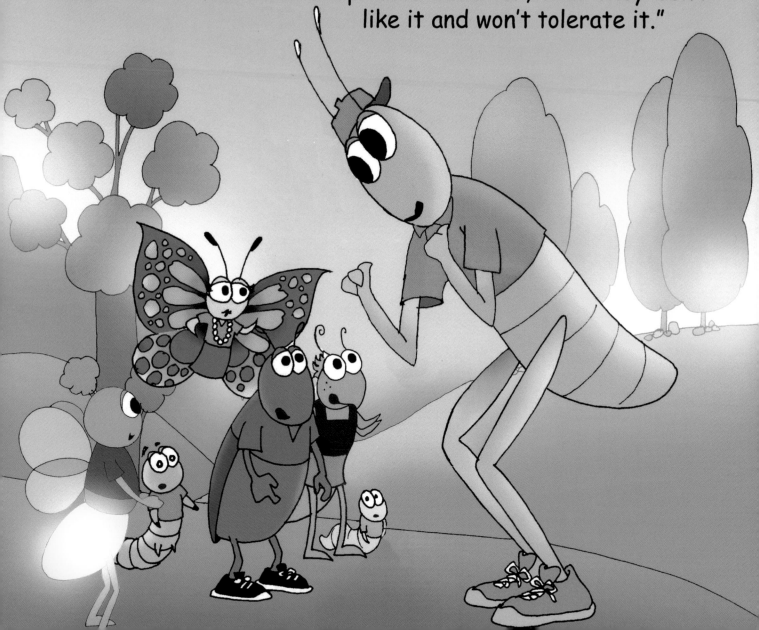

The other students who were listening nodded in agreement with what Gary was saying.

Starting with Juney Junebug and Davey Dragonfly, they went over one by one to Freddie to say they were sorry for not standing up for him and for letting Carl bully him. They apologized for laughing at Freddie and making fun of him. They asked Freddie if he could forgive them. Freddie said, "Yes!" and hugged each of them.

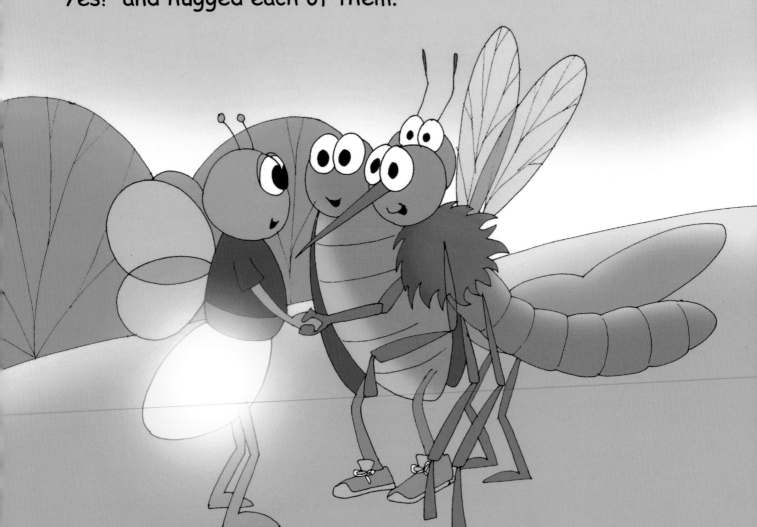

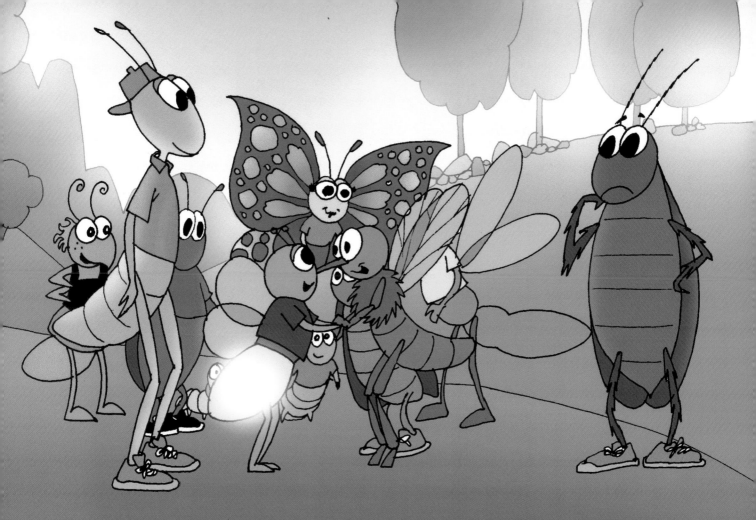

Carl watched as the other students hugged Freddie and suddenly felt very alone and ashamed. He slowly walked up to Freddie and told him how sorry he was, that he didn't think about how much pain and sadness he was causing Freddie. Carl admitted that when he went home after school, he always seemed to feel unhappy and now realized that it was because of the mean way he was treating Freddie.

Carl then asked Freddie if he could forgive him, too. Freddie had been hurt very badly by Carl's bullying, but he decided to forgive him and they hugged each other tightly. Carl felt happier than he had in a long time. He announced to the other students that what he did was wrong and that from now on no one at school should bully another student.

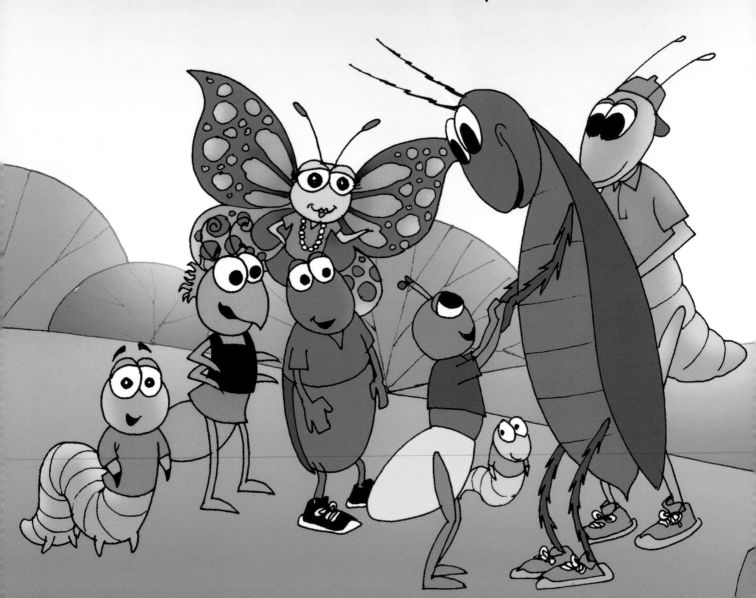

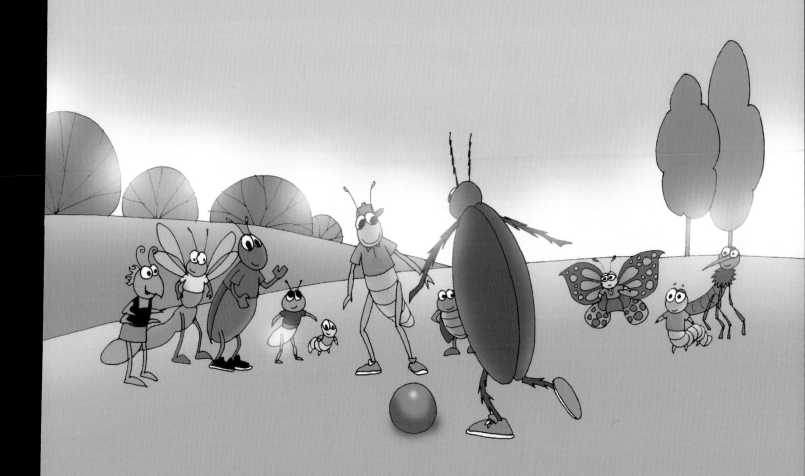

Then Carl asked if they could stay and play kickball, which they did. They were having so much fun that the hours passed by quickly. Soon it was five o'clock and time for dinner, so they said goodbye to Carl Cockroach and the other students.

On the way home Freddie thanked his friends for coming to visit him, and especially Gary for coming to his rescue. He told Gary, "Even though we live so far apart, I know my best friend will always be there for me when I need him and I'll be there when he needs me, too!"

Gary smiled at his best buddy, whose light was shining more brightly than ever. Then Gary hopped higher than ever, he was so happy that everything had worked out for Freddie. The friends high-fived and headed to Freddie's house: all of them happy, hungry, and hopeful that no one would ever be bullied again.

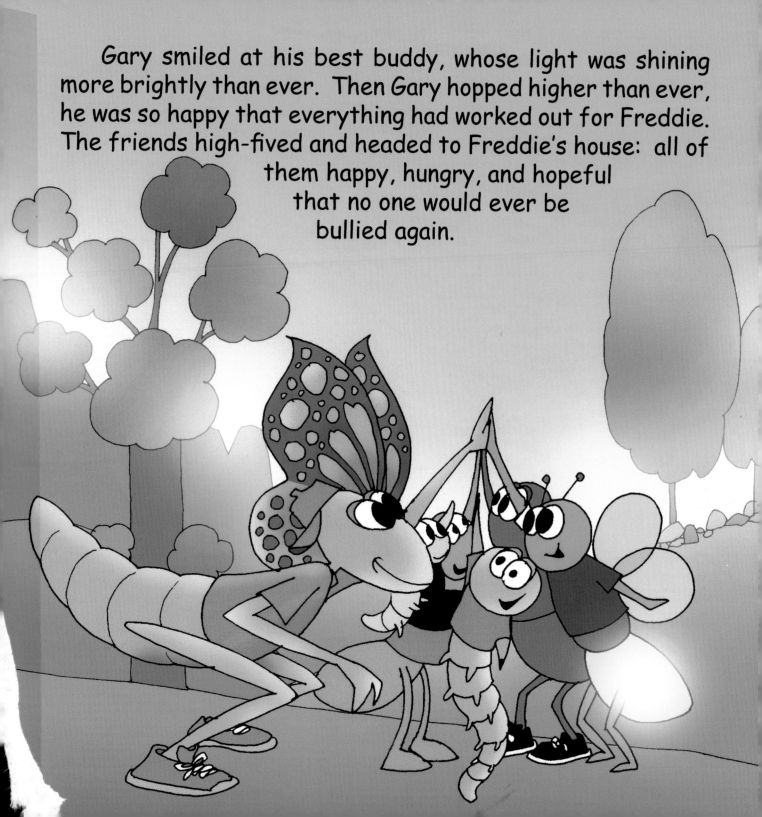

CPSIA information can be obtained at www.ICGtesting.com
Printed in the USA
LVIW01n0702110216
474625LV00003B/6

Made in the USA
Las Vegas, NV
13 November 2020

10885464R00040

Closing Thoughts

My goal in teaching airbrush and outlining the instructional concepts in this book is to always teach in a user-friendly way so that the techniques will stick. Although these techniques are basic and simple to me, I feel like they are rudiments that you will need to go back to, even as you aspire to create more complex imagery. I continually encourage students to keep moving forward instead of getting intimidated by freehand control. Freehand control is monumental in sustaining the learning curve, but you must have other ways to accent and expedite the learning process. The more tools and tricks you can sneak in, the more you can expand your range as an artist. I also emphasize patience. With patience come craftsmanship, clarity, and imagination. Let your art breathe and know when to walk away from a piece as opposed to overworking it. There are thousands upon thousands of surfaces on which to practice. You can airbrush on glass, cars, and T-shirts, and you can create abstract art, body art, and backdrops for photography. The bottom line is to try and have fun, select imagery that mirrors your own interests, and remember that repetition is the foundation of skill.

The finished image reflects the 70/30 rule of working 70% with the airbrush to establish the base coats, block out large areas, and create the initial shading and tonal transitions. For the remaining 30% of the work, bring in additional tools to refine the image and make it more professional. If you choose to do 100% of the work with the airbrush, you may find that it's more labor intensive. This project, along with the others in this book, gives you the fundamentals to refine your skills and know how and when to apply tools to create more appealing work. Remember to choose photo references with intense shadows.

Step Twenty-Three
With a paintbrush, add wisps of hair in dark brown along the hairline and transition the fuzziness of the airbrush strokes into the forehead.

Step Twenty-Four
Add texture to the hair by scraping off paint with a utility knife. DO: Work carefully so the highlights look natural.

Step Twenty-Five
Lightly spray over the scratched areas with transparent yellow then transparent light brown. This subdues the white scratching and adds layers of hair strands.

TIP

Hair can be quite forgiving. If you shade an area too darkly, go back and re-scrape that area and paint it again. You will actually end up with a very nice layered look since you have been using transparent paints to build the foundation of the hair.

Step Twenty-One Position the French curve to isolate the jaw line and render it with light brown. This edge will push the face forward and help establish depth between the jaw and neck.

Step Twenty-Two With transparent dark brown, darken the outer part of the image and leave some of the light brown exposed. DO: Fade out the dark brown from the margin to the middle. Holding your airbrush at an angle will allow you to make a nice transition. Also intensify and add detail to the shadows around the eyes, lips, nose, and jaw line while working close to the surface.

TIP

Check back with your photo reference about every 15 seconds so you can assign the proper value and intensity. Paint what you see, not what you think you see.

Step Nineteen Use a fresh sheet of contact paper to isolate the lips and spray a base coat of opaque pink.

Step Twenty Re-apply the contact paper you cut out earlier over the top part of the lip. Spray an acute edge with transparent red to separate the upper and lower lips.

TIP

Templates vary in thickness. A thinner template will help you create a more crisp and defined edge. French curves come in handy where softer edges are more appropriate.

Step Sixteen With a clean French curve, work close to the surface and spray the perimeter of the nostril. Again, you are sculpting this edge to set up the freehand shading that will eventually bring the shape together as a whole.

Step Seventeen Come in again with the French curve to spray the very subdued "breaking point" of where the shadow stops and the tip of the nose starts to become more defined.

Step Eighteen Lightly shade washes and wisps of paint to smooth and transition out the edges around the nose.

Step Fourteen Freehand shading with tiny little wisps will continue to establish the form and dimension. DO: Taper the edges and fade out certain areas.

Step Fifteen Use a French curve to carefully spray the edge of the nostril on the left with light brown. This is a defining area and will create a good counterbalance to the shadow on the right.

Step Twelve Once again, clean the French curve and reposition it to isolate the other side of the eye. Spray along the edge with light brown. This is called "trapping" a shape at its perimeter, i.e. defining the shape's dimension. This, combined with freehand shading, will create the contour and form of the eye.

Step Thirteen Wipe the wet paint off the French curve and come in to shade, sculpt, and refine the bottom part of the eye. DON'T: Crisscross or overlap your edges.

Realistic Eyebrows and Eyelashes

Eyebrows consist of individual hairs that bend, flow, and overlap together. They are not simply symmetrical lines. Use light brown and a fine paintbrush to add the detail and realism that this area requires. Eyelashes need more of a crescent-shaped stroke, and you may need to retouch these later in the process.

Step Ten Position the French curve just below the upper eye crease and spray light brown along the edge of the template.

Step Eleven Wipe off the French curve so you don't reposition wet paint and come in close to align the tip of the template with the perimeter of the eye. Spray along the edge with light brown to define the eye and create dimension.

Step Eight Add a piece of contact paper over the eyes and use your utility knife to expose and isolate the irises. Masking tape with a fold in the middle will help shield any overspray. As you shade the irises with transparent dark blue, concentrate more paint toward the top to assist the assumption of a shadow or darker area. You can shade directly on and around the pupil to subdue it and maintain a proper color balance. The eyes can have a softer or harder edge depending on your personal preferences and the nature of the composition.

Step Nine Spraying tiny little wisps of opaque light blue close to the surface, transition the color of the eye for a lighter tone on the lower part of the iris. DON'T: Worry about a little bit of overspray getting on the pupil as it will soften it up a bit.

Step Five Remove the masking from the eyes and lips and come in very close to start detailing tiny little wisps that move in a single, fluid direction. DON'T: Become intimidated when it's time to add detail. Work slowly and deliberately, and practice your strokes off to the side if needed before working on the painting surface.

Step Six Use a black marker to fill in the pupils of the eyes, leaving the white highlight exposed. DON'T: Use a marker that leaves a gloss or sheen (usually enamel paint markers) because they will refract light and offset the balance of the image.

Step Seven Working in very tiny wisps close to the surface, soften the hard edges around the eyes left by the mask with opaque white. DO: Be careful not to spray too much white into the color areas when you are blending out the edge or you may get an unwanted titanium shift in which you will have a blue-ish muddy gray tone on top of your existing colors.

Step Two Start mapping the defined shadow areas with transparent light brown. The term mapping refers to defining the isolated shapes of the dominant shadows in order to establish a starting point from which everything else will flow. Also dust light lines as reference points for the creases of the eyes. DON'T: Wave the airbrush back and forth. This will reduce your ability to taper your strokes, and eyebrows, eye creases, and shadows all need to taper.

Step Three Work close to the surface and spray an acute or crisp shadow underneath the lip. DO: Spray along the edge of the lip masking. This edge acuity is one of the refining points in helping the image look more balanced, crisp, and professional.

Step Four Continue to block out and darken the background. Also dust a reference point for the jaw line, which you will later define with a French curve.

Portrait

There is a learning curve when it comes to understanding the elements that make up a good portrait. One of the biggest mistakes you can make is to work from a photo reference in which you cannot see the shadows or different tonal points in the face. If your photo reference lacks defined and acute shadows, your image could end up looking flat or somewhat cartoonish. This exercise will teach you the fundamental elements of building a basic flesh tone and expose you to the principles of portraiture.

Opaque Palette
Light blue, pink, and white

Transparent Palette
Dark blue, dark brown, flesh tone, light brown, red, and yellow

Additional Materials
Black marker, clear contact paper, French curves, masking tape, paintbrush, and utility knife

Step One Lightly sketch the rough shape of a face, neck, and facial features. Apply clear contact paper to the painting surface to protect the eye and lip areas. Expose the rest of the face and neck, and dust over the area with transparent flesh tone.

This is a basic but important exercise in understanding how edges and colors work together to build a composition. The airbrush is very useful to expedite the blending of colors, which can be a frustrating process using traditional painting techniques.

Working with transparent paints (especially when you apply a clear coat) creates a lot of depth since you can see every layer that is applied.

Step Eleven The inner part of this French curve is more appropriate for defining the petals as the curling becomes more and more intense. Continue to transition out this very dark inner area as it is one of the focal points of the rose.

Step Twelve Clean the French curve and reposition it above the long horizontal edge as you continue to develop dimension by spraying along the perimeters of the petals. Working freehand, move around the composition to enhance the shading and blending. Then add a cast shadow with the French curve on the front petal on the left.

Create the Stem

With the original contact paper removed, reapply contact paper to protect the rose and background close to the stem area. Spray an opaque light green base then add a mix of transparent dark green and gray for the outer edges and top of the stem.

Step Eight Reposition the French curve to create another inner petal to the left of the first one. Then lightly add a shadow to layer the petals as you work freehand.

TIP

It is very common to use five different French curves on one flower alone. If you have a variety of these types of templates, select which one you think is most appropriate for the step you're working on at the time.

Step Nine Create the horizontally curling petal using the French curve and dark brown. Lightly blend out the shadow behind it.

Step Ten Continue to sculpt and define the outside of the inner petals. DO: Pay attention to how the shadows are developing and transitioning.

Step Six Isolate the main petal from the one behind it with the French curve and spray dark brown, blending out the shadow as you go. Wipe the French curve clean, flip it to the opposite side and repeat the same action for the background petal on the right. DO: Try alternating between transparent dark brown and red throughout this exercise to build depth in your tones.

TIP

As you reposition a template to sculpt the edge of a shape, vary your spraying distance and trigger pressure for a balance of light to dark and soft to sharp intensities.

Soften the Edges

Hold your airbrush at an angle and wisp little strokes to transition out some of the harder edges.

Step Seven
Reapply the French curve to isolate one of the inner petals and softly spray dark brown as you transition out the shadow. When you isolate a shape at its perimeter and shade behind it, you are simultaneously pushing the image forward and establishing whatever is behind it.

Step Four Working freehand, taper the edge where the two petals meet to blend with the base of the rose. DO: Hold the brush close to the surface, maybe a half-inch away.

Step Three Wipe the French curve clean and flip it over to spray the fold of the petal on the opposite side.

TIP

Using French Curves: Place a transparent piece of tape over the middle of the French curve if you do not want to pick up the inner pattern of the shape as you spray. Always make sure your templates are clean and transparent so you can clearly see where to stop and start spraying.

Step Five Realign the French curve slightly below and to the right of the edge of the petal on the right. Spray another edge to create a shadow area where the petal curls around.

47

Red Rose

Flowers have very subtle and sometimes vibrant color blends and varying edge intensities. This exercise is not only an experiment in the structure and composition of a rose but is a great roadmap in sculpting shapes and forms with basic French curves.

Opaque Palette
light green

Transparent Palette
dark brown, dark green, fluorescent pink, gray, and red

Additional Materials
Clear contact paper, French curves, transparent tape, and utility knife

Step One Sketch the outline of a rose on the painting surface and mask off the perimeter of the shape using contact paper and a utility knife. With a 90/10 mix of transparent red and fluorescent pink, evenly shade a base tone for the flower.

TIP

Fluorescent pink will enhance the chroma or vitality of the red as roses and other flowers have very deep, exotic values.

Step Two With transparent dark brown, shade the fold of a petal using the French curve as a guide. Dark brown is usually a highly pulverized, refined color that gets dark very quickly. DON'T: Use black instead of dark brown. It would be too grainy and dominant, offsetting the tonal balance.

Adding the Final Touches

A deep blue tint finishes the shadow. Using black would be too dominant and could create a grainy look on top of the other colors. Also lightly mist the water drops with the same blue.

Subtractive highlighting enhances the organic texture of the apple. After scratching lightly with a utility knife, tint over the area with deep red to subdue the abrasive nature of this technique.

The final image establishes a good balance between hard edges, soft edges, and smooth shading transitions. Believable textures, such as wood grain and water drops, can add visual interest with minimal effort and simultaneously enhance depth and dimension.

Step Eleven Continue shading with deep red to transition the light and shadow from the middle down to the base of the apple. Then tint the apple very lightly with quinacridone nickel azo gold in different areas to add more vibrancy and depth. DON'T: Spray too much or you'll offset the subtle balance of tones.

Step Twelve Mask the wood grain, apple, and shadow with contact paper. Then tint the lower half of the canvas with a 50-50 mix of light blue and deep blue. After removing the mask, soften the shadow by blending the color into the edges using tiny, wisping strokes that allow the color to taper out.

Rendering the Stem

Be sure the contact paper masking the stem has been removed. (A) Then freehand tint light brown, olive green, and raw umber to achieve the color blends in the stem. (B) Take a utility knife and scratch texture into the paint. A final tint of transparent light brown covers the scratches and blends all of the colors together.

Step Eight Cut several raindrop shapes on a piece of transparent blue acetate for the next template. Again spraying 75% on the template and 25% on the surface, render the cast shadow of water drops on the apple using opaque white. DO: Get very close to the surface when working at this scale to create a defined cast shadow for the drops.

TIP

The more transparent the template material, the better you can see the stopping and starting points of the edges you are rendering. Turn to page 7 for more details.

Step Nine Render the backside of the water drops in deep red using the same template. Again, hold the template and spray very close to the surface to achieve a more acute edge.

Step Ten Position the template right above the border of the cast shadow and spray opaque white for the highlight on the water drops. Fading out the white creates the transparency of the drop. Then move the template around randomly to sculpt the different water drops.

43

Step Five Mist burnt umber in both thick and thin vertical strokes as a counterbalance to the vibrant hue of the transparent light brown.

Step Six Remove the sheet of contact paper covering the apple and place a fresh sheet over the canvas. Cut around the apple and its shadow using a utility knife. This time, leave the upper and lower background covered and expose the area for the shadow and apple – except for the stem, which remains covered. Then use Goo Gone on a microfiber towel to dissolve any residue. Using deep red, begin shading the apple, and leave white areas that will highlight the shape. Working close to the surface allows me to add detail and hard edges. As you pull the airbrush back 4-5 inches, you are filling in larger areas and transitioning and blending out the smaller strokes (gradients).

Step Seven A curved template cut freehand from transparent frosted Mylar isolates the inner core of the apple. Still using deep red, spray 75% on the template and 25% on the painting surface. Hold the template ¼-inch away from the surface to create a softer, more subdued edge. After each pass, wipe the template clean with a spare cloth to prevent accidents and repositioning of the paint. Finally, remove the contact paper from the canvas to clearly see how the image is coming together.

TIP

You can use an artist's fan brush as an alternative to the mascara brush. Pick up mascara brush samples at beauty supply stores and simply rinse them with water or airbrush cleaner after use.

Step Three Use light, even strokes to mist light brown over the raw sienna-golden yellow basecoat. Building colors from light to dark allows more room for error and the ability to rework areas that are too heavily sprayed.

Step Four After tinting the entire background with light brown, use the same color to render both thin and thick vertical streaks. DO: Work closer to the surface now to suggest the organic and subdued nature of the wood grain.

Adding Texture

Focusing on texture adds realism and depth to the wood grain. (A) While the paint is still wet, use your finger and quickly smear the paint in tapering strokes to enhance the flow and texture of the wood grain. (B) Dip a mascara brush in dark brown and slowly drag it flush to the surface to create a linear pattern to further accent the texture. (C) Using a utility knife, scratch highlights for additional texture. This subtractive highlighting process is very useful to enhance realism.

A B C

Still Life

This exercise helps beginners understand shading and texture in a composition. The use of freehand templates and contact masking as demonstrated in this project is an essential part of refining and tightening an image to achieve better continuity via hard and soft edges. Using different intensities of edges in a composition helps to establish balance.

Opaque Palette
Burnt umber, light blue, olive green, raw sienna, raw umber, and white

Transparent Palette
Dark brown, deep blue, deep red, light brown, quinacridone nickel azo gold, golden yellow

Additional Materials
Clear contact paper, blow dryer, Goo Gone, mascara brush or artist's fan brush, template, towel, and utility knife

Step One Draw the image in pencil and apply a clear sheet of contact paper to the canvas. With a utility knife, trim around the perimeter of the apple and remove the contact paper from the background. The apple area is now masked and protected. Spray a light mist of Goo Gone to remove any remaining adherence left from the contact paper. Then I use a blow dryer to evaporate any residue from the Goo Gone. You can also apply a strip of masking tape to establish the horizontal border between the wood grain and blue surface.

Step Two Using a 50-50 mix of raw sienna and golden yellow, mist a foundation for the wood grain on the upper half of the canvas. Beginning with this base tone will later help the transparent colors retain their depth for more realistic texture.

This exercise allows you to develop an understanding of the predominant elements needed to create a metallic surface with an airbrush. You can apply these same techniques to other compositions that incorporate various types of metals.

Step Twelve With transparent light blue, work close to the surface and lightly dust over the entire kettle to intensify and exaggerate the light refraction. Depending on the intensity of light hitting the object, metal usually has certain hints of blue.

Step Thirteen Add a wisp of soft highlight to the black edges of the handle and a tiny dot to the black knob of the lid with opaque white.

TIP

Optional finishes can add more texture to metallic surfaces. Try adding detailed white or black lines with a paint brush, scraping off paint with a utility knife or electric eraser to add distress, or creating detail with a pencil. Light touches of transparent purple can also add further depth.

Step Nine Remove the contact paper from the base of the kettle and add areas of soft highlights with opaque white on the right side. DON'T: Overspray or you will negate the transition of light to dark.

Step Ten Adding a tapering white highlight to the left side will enhance the believability of the light refraction. DO: Use more of a vertical cat claw stroke as opposed to the basic dagger stroke.

Step Eleven Cover the black ends of the handle with a piece of masking tape and add opaque white highlights to the edge of the handle. Work close to the surface and wisp your strokes in a single direction. DO: Try about 20 practice strokes off to the side to perfect your technique before spraying on your painting surface.

Step Six Work close to the surface to outline each side of the handle. DO: Spray about 75% on the contact paper and 25% on the painting surface to create dimension. Then lightly spray a middle stripe to show the refraction of light and shadow on the surface of the handle. Leave the ends where the handle connects to the base of the kettle blank.

Step Seven Grab the piece of contact paper that you cut from around the base of the kettle earlier and re-apply it. Spray the bottom of the kettle solid black.

TIP

If you re-mask an area that you have already painted, it is sometimes necessary to spray a light mist of fixative or matte finish onto the surface to prevent the re-applied contact paper from lifting off paint.

TIP

Sneaking in a quick piece of tape is a good way to isolate areas quickly without having to continuously apply and cut contact paper.

Step Eight Leave the base of the kettle masked with contact paper and isolate the ends of the handle with masking tape. Spray these inner parts of the handle with black, as well as the rounded knob on top of the lid.

Step Three Working close to the surface with transparent black, shade around the spout and intensify the darker areas on the right side of the kettle with precision. DO: If you're working from a photo reference, pay close attention to how the light refracts differently in different areas.

Step Four Add a thinner, refined stripe of gray on the left side to serve as a counterbalance to the thicker, fuzzier stripes. This will draw the eye in and help establish the contour of the shape.

Step Five Lightly shade the left side with gray and add a hard edge to the perimeter. The hard edges combined with the soft stripes will ultimately establish the form of the kettle.

Tea Kettle

The smooth texture and refractive qualities of metal are easy to reproduce with an airbrush if you pay close attention to the nuances of lighting and shading. Metal often catches the viewer's eye in a composition because its smoothness contrasts nicely with more organic textures. The shading you use for metallic surfaces will depend on the shape of the object, light source, and quality of the photo reference.

Opaque Palette
white

Transparent Palette
black, gray, and light blue

Additional Materials
Clear contact paper, masking tape, ruler, and utility knife

Step One Lightly sketch a tea kettle on the painting surface and cover the surface with clear contact paper. Use a utility knife to cut around the shape and expose the kettle. With transparent gray, spray a shadow on the right side of the kettle using a ruler as a guide. DO: Hold the ruler slightly away from the surface as you spray so the shadow is not too defined, which could make the image look more animated and negate the realism.

Step Two Add more vertical stripes of gray for the different variations and tonalities of the metallic surface. DO: Work close to the surface for a darker distinction, and pull back to create subtle transitions between the shadows to reflect the contour of the kettle.

The focal point of this exercise is to understand, identify, and align the elements of contrast in glass to reveal the refractive and transparent qualities. The nature or degree of transparency depends on the intensity of the lighting and the colors used to support that lighting.

TIP

If this glass had a brown background, you would use opaque light brown, transparent dark brown, and opaque white in the color palette.

Step Eleven With a French curve and opaque white, get very close to the surface and loosely spray the highlight on the center part of the glass. Adding this white against the blue will establish a nice titanium shift or bluish-white cool tone. DO: Avoid overspray through the inner patterns of the French curve by covering each side with transparent tape.

Step Twelve Use the same opaque white for freehand vertical highlights on the sides of the glass to establish the contour.

Step Thirteen Get in close and lightly tint over some of the white highlights that may be too vibrant with transparent deep blue. DO: Place a piece of contact paper on the surface and lightly spray the area you are tinting. This allows you to test the intensity of the paint before jeopardizing the image.

TIP

Opaque white and black can clog the airbrush quickly because of the amount of pigment they contain. Adding a reducer to your paint (three parts paint, one part reducer) will enhance the flow of paint and allow you to add detail.

Step Eight Cover the surface with fresh contact paper and cut around the shape of the glass using a utility knife. Leave the glass covered and spray transparent deep blue to fog out the background. A dark background will help retain the logic of light being refracted through the glass, thus creating the illusion of more transparency and depth.

Step Nine Take a piece of masking tape and horizontally isolate and spray the area the glass is sitting on with transparent deep blue. DO: Put a bend or crease in the tape to prevent overspray from traveling.

Step Ten Below the dark blue in the upper background, leave a void white area to show the light refracting through the center of the glass. Below this white area and above the surface the glass is sitting on, fog in opaque light blue and blend a gradient of tone to enhance the ambience and dramatic characteristics of the light.

Step Five With transparent deep blue, spray thin and thick, vertical strokes to enhance the darker areas of refraction. DON'T: Wave the airbrush back and forth. DO: Wisp the brush in a single direction to taper and shade out the strokes. This is known as a cat claw or vertical dagger stroke.

Step Six With the same transparent deep blue, get very close to the surface and spray curved lines next to the crisp black segments. Soft detailed freehand strokes that contrast with the crisp segments will create the illusion of depth and transparency.

Step Seven Use a paintbrush and very acute tapered strokes of opaque white to add highlights amid the deep blue and black areas. These strokes in conjunction with the black tapering segments will be very appealing to the eye from a distance and add a realistic depth to the glass.

Step Two With a utility knife, cut out the areas of the glass that will be black. Cutting these areas with precision and paying attention to how they taper into a point is essential in manipulating the eye. These sharp tapering areas will create a realistic nuance, especially from a distance.

Step Three Spray transparent black over the exposed areas. DO: Spray lightly and evenly to prevent the paint from bleeding underneath the contact paper.

Step Four Remove the contact paper covering the glass and lightly fog opaque light blue as the undertone or foundational tone. This will establish the first layer of transparency. DON'T: Spray too much into the white areas because it will ruin the contrast.

Glass

The airbrush is the perfect tool to trick the eye to put together the visual elements of glass. Glass has crisp tapering segments of black and fine white accenting paintbrush strokes contrasted with soft airbrush color blends, freehand strokes, and masking applications. You can render glass as a fine art concept or as a graphic concept for sign applications or commercial-based art. This basic approach will lay the groundwork for the needed elements of a good composition.

Opaque Palette
light blue, white

Transparent Palette
black, deep blue

Additional Materials
Clear contact paper, French curves, marker, masking tape, paintbrush, transparent tape, and utility knife

Step One Start by placing clear contact paper over the painting surface. Then draw the glass on top with a marker.

Blending Into the Background

Take your utility knife and scratch around the perimeter of the feather. This splits the edges in certain areas to make the feather look more natural and to help it mesh with the background.

The finished image is a result of blending colors and using loose masking to create a realistic feather. You can certainly employ other techniques. Many people will freehand every stroke and not depend on any template or loose masking. I often choose to utilize whatever gets the job done the fastest. You have the freedom to make the artistic decision regarding how much time and refinement you want to incorporate into an image.

Adding Texture

With a utility knife, add texture to the feather by lightly scratching at a consistent angle from the edge in toward the stem. DON'T: Get too aggressive or scratch in a manner that does not flow naturally with the shape of the feather.

Step Five Working with transparent dark brown starting about an inch from the surface, intensify the tone transition and pull back to fade out. DON'T: Cover up too much of the light brown in order to retain a good color transition from dark brown to light brown to yellow.

Step Six Clean up the yellow overspray on the stem by carefully working close to the surface and spraying opaque white down the length of the stem. Enhance the cast shadow on the bottom side of the stem with light brown and add a shadow to the underside of the feather. DO: Taper out the strokes and wisp the airbrush in a single direction.

Step Two With transparent light brown, get close to the surface and dust around the perimeter of the feather. Then shade the tip, transitioning to a lighter tone as you work toward the middle. DO: Spray about 75% on the contact paper and 25% on the painting surface to maintain a reasonable color balance.

Step Three Reapply the stem masking and continue spraying with light brown to create a cast shadow that's heavier on the underside of the stem. The closer you get, the darker the shadow will be. DON'T: Spray too far back or the stem may look fuzzy and unrefined.

Step Four Hold the blackbeard wheat angling away from the stem and use it as loose masking to create the organic nature of the feather. Lightly and evenly spray light brown over the masking and reposition it as you work around the feather. This will save a lot of time compared to creating this texture freehand.

Feather

Painting realistic feathers with an airbrush is easy as long as you know the proper sequences and techniques to apply. Feathers have many uses in fine and commercial art, as well as body art since you can use the airbrush on any surface. This exercise will once again make use of loose masking to build a dynamic image.

Opaque Palette
raw sienna, white

Transparent Palette
dark brown, light brown, and yellow

Additional Materials
Artificial feather, blackbeard wheat, clear contact paper, towel, and utility knife

Step One On a surface covered with clear contact paper, cut out and expose the shape of a feather. Take the stripped stem of an artificial feather and hold it in place in the middle of the shape. Evenly spray a base tone comprised of a 50-50 mix of raw sienna and transparent yellow.

TIP

You should be able to find the items needed for loose masking in this exercise at any craft store. You will need an artificial feather stripped down to the stem and a clump of blackbeard wheat, usually found in the décor section. Instead of blackbeard wheat, you can use a small whisk broom or anything with a fine grass-like texture that doesn't move too much when sprayed. Dab the paint off of your loose masking items with a towel before repositioning them for another pass.

You can use granite as a faux application on walls, a commercial art technique, or as a fine art element. The airbrush gives you an incredible advantage over other mediums to create smooth shadow transitions and subdued edges. This realism will really draw people into your work.

TIP

For less realism and more of a commercial look, try using transparent instead of opaque paint for the base tone of granite or stone.

Step Four Rinse the toothbrush clean and stipple more texture in opaque white. The white enhances the organic nature of the granite and contrasts well with the black. DO: Make sure the white paint is as thick as possible. It sometimes has a tendency to dissipate or fade with a reducer.

TIP

The relevant color palette applies to every element of the granite. For example, if this were a brown stone, the cracks would be dark brown.

Subtractive highlighting

Hold the utility knife at a 10–20 degree angle and gently scrape off some of the paint for subtractive highlighting on (A) one side of the cracks. Add more detail (B) by scraping one side of the stipple spots to create tiny highlights. DON'T: Overwork the effect unless the specified image calls for an abundance of distress.

Step Five Take a paintbrush and freehand the distressed cracks in opaque black. DO: Imagine you are painting lightning bolts. Then connect the bolts in certain areas.

Step Two Tape a piece of ripped poster board a half-inch inside the perimeter of the shape. Render a distressed edge around the entire slab of granite in opaque gray. DO: Spray darker and closer to the surface than in the previous step.

Step Three Take a toothbrush dipped in opaque black and, using your thumb, flick dots onto the surface to create texture. This is called stippling. DO: Make sure the paint isn't too thick or it will run down the surface, and you'll have to start over.

TIP

A piece of ripped poster board will help you shape the edges of the granite slab. Rip the poster board in a similar manner to the accompanying edge to maintain the integrity of the beveled area of distress. Wipe the paint off the poster board with a towel after each pass.

Granite

This is a great foundational exercise because it has many of the essential components, such as dimension, form, and texture, that you need in a basic composition. The airbrush lends itself very well to balancing the distressed and speckled attributes of granite, the colors and textures of which can be highly diverse.

Opaque Palette
black, gray, and white

Additional Materials
Clear contact paper, masking tape, paintbrush, poster board, toothbrush, towel, and utility knife

TIP

To fog or dust means to hold the airbrush about 10 to 12 inches away from the surface while spraying.

Step One Cover a surface with clear contact paper and cut out the shape of a chiseled granite slab. Remove the contact paper from the granite shape and fog an opaque gray base.

Step Six Add about six drops of transparent blue to opaque white paint and randomly dust different areas to add a hint of color to the veining.

Step Seven Fine tune and add more detail in opaque white using a paintbrush or airbrush. I call this "webbing" the pattern out or tapering the veins where they dissipate.

To add an optional shine to the marble, spray a clear coat over the surface. Be sure to stay away from satin clear coats as they will turn the surface yellow and ruin the effect.

TIP

Keep in mind that there are many different colors and types of marble with more or less complexity in the texture. Marble does not have to be overworked to be effective. It just has to flow and have a good balance of positive and negative space.

Step Three Randomly dust certain areas on the perimeter of the rectangle. This draws the eye in and establishes a border or perhaps suggests distress on certain areas of the surface.

TIP

Avoid transparent paints for this technique. They can be overtly vibrant and negate the realism of the texture. Opaque paints will retain muted points of saturation and neutrality and assist in the aesthetic balance of the composition.

Step Four Dip a paintbrush in opaque white. Holding it at a 10–20 degree angle, blot some erratic brush marks onto the surface. This will help establish the organic appearance of marble and provide a nice contrast with the soft gray.

Step Five While the white paint is still wet, blot the pattern in different areas with a towel. This will take some of the paint off the surface and create softer, muted areas so the white looks embedded in the marble.

Marble

An airbrush is ideally suited to creating the smooth veining and soft edges of marble. You can apply this texture in commercial art, inside a font, as a faux concept in décor or murals, and even on furniture.

Opaque Palette
gray, white

Transparent Palette
blue

Additional Materials
Clear coat, clear contact paper, masking tape, paintbrush, poster board, towel, and utility knife

Step One Apply contact paper to the surface and cut out and expose a basic rectangle. Lightly spray freehand horizontal strokes of opaque gray. Then, render a soft vein using a ripped piece of poster board as a guide. Move the poster board to the opposite end and spray another vein. If needed, use masking tape to keep the poster board in place. DO: Keep your eye on horizontal alignment.

Step Two With the same opaque gray, softly freehand lightning type strokes to add more of the subdued texture.

Cube

Step One Draw a cube on top of clear contact paper applied to the painting surface. Cut out and expose the front of the shape. Then add masking tape around the perimeter of the contact paper to prevent overspray from traveling. Spray the front of the cube in a full tone of solid black.

Step Two Isolate the side of the cube with the straight edge of a piece of poster board and spray a half tone here. Spray about half of the value intensity or darkness of the front.

Step Three Reposition the straight edge and spray a quarter tone on the top of the cube. Spray about half of the value intensity of the side of the cube or a quarter of the value intensity of the front.

Step Four Softly at an angle, render a cast shadow to help accent the dimension and light source.

TIP

Applying loose edges, templates, or stencils is called loose masking. This expedites the sometimes arduous process of contact masking.

Cylinder

Step One After drawing a cylinder on top of clear contact paper, cut out and remove the base of the cylinder. Leave the top area covered. Add masking tape to the outer edges of the contact paper for overspray protection. Start shading the right side of the cylinder at about 5 inches back in heavier, longer strokes. Gradually pull back to about 10 inches to create the shadow transition and form. (Note: The red "x" marks indicate the part of the shape that is covered with contact paper.)

Step Two Working 3-5 inches from the surface, shade the other side of the cylinder with about 25 percent of the intensity of the right side and less of a shadow transition. This creates the form and dimension of the shape. A white vertical area is left void to reflect the hottest point of light.

Step Three Remove the contact paper from the top of the cylinder, and re-apply the contact paper to the base. Spray a light tone on the top then move toward the middle to render a hint of a shadow.

Step Four Remove all masking and render a cast shadow at an angle working about 2 inches from the surface. This will further establish the light source.

TIP

Isolating and covering one section of an image while exposing another section is called contact or sequential masking.

Basic Shapes

Understanding the dynamics of light source, shading, form, and dimension is essential in constructing a good composition. These basic approaches will help you master control.

Sphere

Opaque Palette
black

Additional Materials
Clear contact paper, masking tape, marker, poster board, and utility knife

Step One Apply clear contact paper to the painting surface and draw a sphere on top. Use a utility knife to cut out and remove the circle. Holding the airbrush at a slight angle about 3-5 inches off the surface, lightly mist long crescent strokes in the shadow area.

Step Two Now working about 1 inch off the surface and still holding the airbrush at an angle, use the same long wisps to refine the contour of the sphere. Pull the airbrush back slowly to transition the shadow out softly. Leave the middle and upper left area void of paint to establish the point of light or light source.

Step Three Holding the airbrush completely still, pull back 3-5 inches to spray a shadow underneath the base of the sphere. This suggests suspension or floating and can enhance the 3D qualities. When finished, remove the contact paper to reveal the sphere.

Lines and Shadows

A

B

This basic exercise will help you understand the velocity of how much paint and air your airbrush is releasing. (A) First, work closely to the surface (about an inch away) and practice making these interlacing loops. You'll notice that working this close to the surface gives you a darker tone. (B) Now, lift the airbrush farther away to render a softer, lighter drop shadow. Angle the brush to the right of the original line and repeat the movement. Pay attention to the position of the airbrush to develop a better understanding of where the airbrush is vs. where the paint lands.

Gradient

A

B

Block off a rectangle on a painting surface with masking tape. (A) Working about 3-5 inches from the surface, wisp the airbrush across the top of the rectangle. Continue wisping in the same direction as you work your way down, pulling back to a maximum of about 10 inches as you transition out the tone. (B) Then work about an inch or so from the surface (this is called piercing) to refine the gradient and further enhance the dark to light transition. Continue wisping in the same direction, either from left to right or right to left, to establish an even tone, also known as shading acuity.

TIP

Once you remove any masking, you may notice that overspray has traveled past the perimeter of your gradient or image. If this occurs, lightly dust the overspray with opaque white. Remember to work from lighter to darker to give yourself more room for error.

Airbrush Fundamentals

Remembering to work from bigger to smaller and lighter to darker will help you achieve the right balance of shading, tone, and intensity.

Bigger to Smaller: Working larger will enable you to taper your strokes with greater ease and help you fade and blend your colors. You will also have more room for spraying and be able to better understand your spatial awareness, i.e. how close you are to the surface. Working smaller allows for more detail and refinement but is also more stressful on your hands.

Lighter to Darker: Start each image by working very lightly and subtly. This entails working farther from the surface. Slowly and progressively build to darker tones by working closer to the surface. It is always easier to fix something as long as you have not sprayed too heavily. If the image gets too dark too soon, you may have to go back and make painstaking corrections.

Practice Exercise

Create a pattern of synchronized dots and practice your strokes by connecting two or more of the dots in a single stroke. This will help you develop horizontal and vertical control. Notice that the angle (10–30 degrees) of the airbrush allows you to vary the tapering of the stroke. You may also use two hands if you like. Using two hands will displace the weight of your arms in a more balanced manner as you are moving up and down or side to side.

> **TIP**
>
> *The foundation of control will always revert to moving or "wisping" the airbrush in a single direction and laying the paint evenly and smoothly. If you wisp or wave the airbrush back and forth you could end up with very unattractive patches.*

Line Discrepancies

There are three predominant discrepancies to look for when troubleshooting the continuity of the paint or airbrush. These discrepancies can work together or alone to create problems. It's also important to note that, even if none of these conditions are present, you could have purchased bad paint, the surface may need different preparation, or the room temperature could be effecting the saturation.

A

B

C

Caterpillaring (A) is often the result of paint that has been mixed too thin. Working on a non-porous surface, such as glass or metal, can also cause this effect. You should always spray lightly and evenly on hard surfaces that tend to repel paint. A blow dryer will help keep the surface warm and assist the adhesion of the paint.

Spattering (B) happens when your paint is too thick or your pressure is starting to dissipate and getting low. An ideal operating pressure for spraying is about 50 psi and higher for 70 percent of airbrushes. More expensive airbrushes tend to function more efficiently at 40 psi; the internal components are more hypersensitive to higher pressures.

Trailers (C) are intermittent dots in your lines that indicate the accumulation of "tip dry" or paint that has formed through the atomization process of the brush. To avoid this, scrape off the tip of the airbrush about every five minutes or so using your fingernail. This will free the airflow. Trailers can also indicate that your paint needs a flow enhancer or reducer to improve the continuity of the spray.

TIP

Maintain a room temperature of 75 degrees and above for acrylic paints.

Basic Techniques

Instruction will only go so far in teaching the dynamics of airbrush control. Repetition and practice, as well as patience and perseverance, are vital to understanding the technique. You will need to acclimate yourself to the weight of the airbrush, the softness of the trigger, and the peripheral view of how close you are to the surface.

Dagger and Feather Strokes

The dagger stroke (A) is the universal stroke in airbrushing. All control is learned from the mastery of this stroke. There are three components:

1. The angle of the airbrush while spraying (normally a 10–30 degree angle when shading and tapering, and straight-on when sketching and establishing placement of the object or letter).
2. The speed in which you spray. This will vary the continuity and tapering of the stroke.
3. The amount of pressure on the trigger of the airbrush.

The feather stroke (B) is a thicker, softer dagger stroke rendered with your airbrush lifted farther from the surface.

TIP

A balanced composition will contain variations of these two strokes.
It is common to practice these strokes hundreds of times before achieving
any type of real proficiency.

Ventilation Box

A ventilation box, positioned chest level or higher, with a fan and air filter inside can help protect your lungs from the overspray circulating in the air as you work. Many airbrush artists paint for years without a ventilation box simply because they can't always see this overspray and assume there is not much circulating. However, once you have a ventilation box on for a couple of hours, you will see the paint that has collected and could have otherwise accumulated in your lungs.

Projector

An opaque projector greatly increases the speed of transferring an image to the painting surface. The difference in projectors typically lies in the quality or thickness of the lens. A thicker lens will allow you to get a clearer, more precise projection and will also cost you more. Many professional illustrators and fine artists use projectors to meet deadlines and keep their labor costs down. It is a very valuable tool.

Electric Eraser

An electric eraser is another tool to consider using for subtractive highlighting, which creates complexity and realism if done properly. Be careful to use a low rpm so you don't jeopardize the painting surface.

Paintbrushes

Keep an array of paintbrushes on hand to tighten and refine details, such as painting eyebrows on a portrait or rendering the crack on a piece of stone. Adding this higher level of detail ultimately leads to a good balance in your compositions.

Templates

Cutting your own French curves and freehand templates (A) out of plastic sheets or Mylar allows you to create whatever shape or contour the project requires. Use a stencil burner (B) to cut out the templates then refine the edges with a rotary tool (C) and sanding sponge so the paint doesn't bleed under the templates as you're spraying. Work on a metal cookie sheet or piece of glass so the stencil burner doesn't harm your tabletop surface.

Accessories

Every project in this book makes good use of clear contact paper (A), which provides masking for large areas. Standard masking tape (B) allows you to quickly create tape walls that prevent overspray from traveling or to easily isolate or cover certain areas before or after applying paint. A utility knife (C) is useful for adding texture with subtractive highlighting, which involves removing paint from the surface.

TIP

Utility knife blades dull quickly but can be sharpened with a sharpening stone to prolong their use.

Airbrushes

The pros and cons of different airbrushes can be discussed at length but, at the end of the day, it's about what works best for you. If you can find an airbrush that can spray larger amounts of paint and deliver good detailed strokes without causing hand cramps, you will be able to work comfortably and effectively. Many airbrush artists have many different types of airbrushes for different needs.

Some variables to consider in selecting an airbrush include:
- Ergonomics. The weight displacement and comfort of the airbrush compared to the weight and shape of your hand.
- Project Scale. Whether you will need to blast a high volume of paint, create detail, or both.
- Trigger Sensitivity. How the airbrush responds to pressure on the trigger can increase or decrease your level of control.

Cleaning Tools

Teflon key rings are a must for cleaning the detailed components of an airbrush. They are usually very durable and solvent resistant, and they hold up well to many different types of liquid airbrush cleaners. You can sometimes substitute a toothbrush or other brushes with small bristles.

Air Compressors

An air compressor from a hardware store will likely be cheaper and last longer than a standard airbrush compressor from a craft store. These compressors provide pressures up to 100 psi or higher and are very portable.

You may want to use designated airbrushes for different types of paint as opposed to switching between paint types in a single airbrush. This will make it easy to choose which cleaner to use if you are having trouble with clogging.

Paints

The type of paint used in airbrushing varies by personal preference. I typically use water-based airbrush acrylic paint or everyday acrylic paint enhanced with water and reducer. Any type of paint needs to have a thin consistency similar to skim milk in order to flow through the airbrush with continuity. I use 2 oz. bottles to mix 50% paint, 25% water and 25% reducer to achieve the desired consistency. Shake the contents before spraying.

Air Pressure

Adequate air pressure keeps the paint flowing well. I typically use 40–50 psi for larger scale imagery and 20–30 psi for small-scale concepts.

Cleaners

It is very important to use the proper cleaner for your paint, i.e. acrylic-based cleaners for acrylic paints and solvent-based cleaners for solvent paints. A solvent-based cleaner will not be able to break down acrylic paint, leading to clogging and intermittent flow.

Palette

For the projects in this book, you will need both opaque and transparent paints.

Opaque Colors

These colors include black, burnt umber, gray, light blue, light green, olive green, pink, raw sienna, raw umber, and white.

Opaque paints are usually foundation or base-coat types of paints, used in more neutral, subdued, and natural types of scenarios. They contain less pigment and usually clean up easily with hot water and a towel. They will:

- Not get darker as you apply more and more of them
- Accumulate and block light quickly when sprayed
- Rapidly lose their luminance (or degree of transparency)

Transparent Colors

These colors include black, blue, dark blue, dark brown, dark green, deep blue, deep red, flesh tone, fluorescent pink, golden yellow, gray, light blue, light brown, quinacridone nickel azo gold, red, and yellow.

Transparent paints contain more pigment and acrylic resin. They used more extensively with glazing techniques. They will:

- Continue to darken as you continue to apply them
- Allow light to pass through multiple layers when sprayed
- Maintain a degree of transparency through many layers